712
MORE THINGS TO ~~DRAW~~ Sketch

Property of:

Jenna

CHRONICLE BOOKS

SAN FRANCISCO

Library of Congress Cataloging-in-Publication Data available.

ISBN: 978-1-4521-0882-7

Manufactured in China.

Design by Eloise Leigh

10 9 8 7 6 5

Chronicle Books LLC
680 Second Street
San Francisco, CA 94107

www.chroniclebooks.com

an envelope

a monocle

a paperweight

an ascot

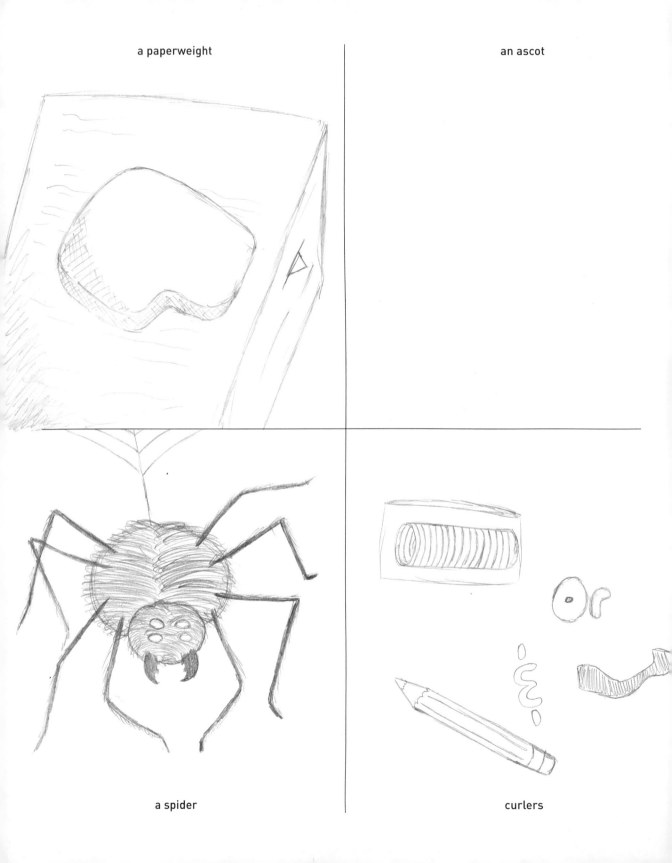

a spider

curlers

a salad

Achilles' heel

Nov. 25th
2016

bamboo

a grandfather clock

your bedroom

a feather duster

a churro

a smelly cat

a cookie jar

boxes

laurels

dancing shoes

a frown

silk

the Sahara

a mermaid

taffy

a sword

a wizard

a clown

twins

a brooch

a turkey baster

a leprechaun

lice

stardust

starfruit

a sponge

a pelt

grass

a dandelion

a baboon

nesting dolls

a jack-o'-lantern

a potion

a stamp

a torch

wings

dust bunnies

a screwdriver

a stethoscope

a jester Andy Warhol

a camera

pizza

a nose

a milkshake

a nickel

a sphinx

riding boots

a compass

Crazy Horse

a skull

a secret hideaway

the sun

a meerkat

a briar patch

a light saber

a pincushion

wallpaper

Australia

Antarctica

a Fabergé egg

cheesecake

a bonsai tree

a fedora

bagpipes

a pair of jeans

a ball gown

3-D glasses

handcuffs

the White House

a lighthouse | a mullet

a chalice

a seahorse

a polar bear

a genie

a bouquet

a giant peach

a barbershop quartet

a dream catcher

a French twist

a Dalmation

a stagecoach

a fanny pack

a foot

Michael Jackson

pajamas

a nutcracker

an elf

a pretzel

a thumbprint

a jewel

a meadow

sugar

pie in the sky

trash

an eyebrow

a claw-footed bathtub

a colonnade

a zipper

an escalator

a parka

a French horn

a shark

an elbow patch

an attic

a fireplace

a flying saucer

a keytar

a rubber duckie

jacks

cleats

a Hula-Hoop

a passport

a dachsund

a couch

a thermometer

a pogo stick

incense

a lasso

sea glass

a memory

a happy clam

a yo-yo

a matchbook

a whistle

an iris

a rooster

suburbia

a scooter

a vase

a Ping-Pong paddle

caviar

a porch swing

an otter

an egg roll

a toothbrush

medicine

a gold coin

a blender

legwarmers

a beach ball

a telegram

a briefcase

a syringe

an elevator

a witch

a parasol

a hedgehog

a macaron

a saddle

a monster truck

a reindeer

Stonehenge

an echo

silence

a sausage

hot pants

a canopy

a scar

a Frisbee

a hot-air balloon

spaghetti

a koala

a cantaloupe

a troll

a swing

a hatbox

a hairbrush

a bullfrog

a werewolf | a silo

a wagon

a harp

headphones

a fishbowl

a cherry pie

a magic wand

onion rings

a gazebo

a corset

a magnifying glass

honeycomb

a puddle

corn chowder

Woodstock

a meat grinder | a tambourine man

a jetpack

a teepee

a smirk

a scarecrow

cellophane

nachos

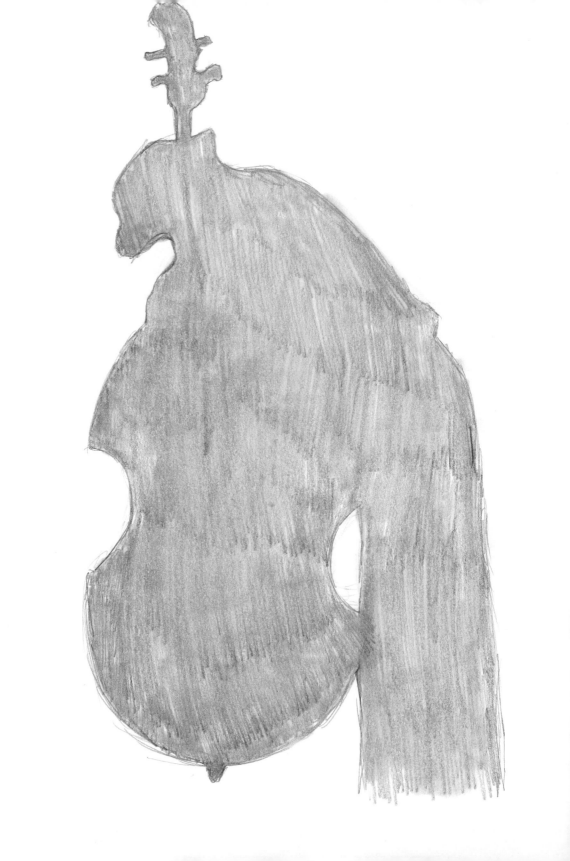

a pack of wolves

a tree stump

a leaf

nunchucks

fudge

a fountain

a fork

a paper crane

a notepad

a cloak

a scrunchie

a snail

a jar of fireflies

a rat

knuckles

a gargoyle

a bandana

a piñata

hopscotch

a friendship bracelet

a carabiner

a garden

rice

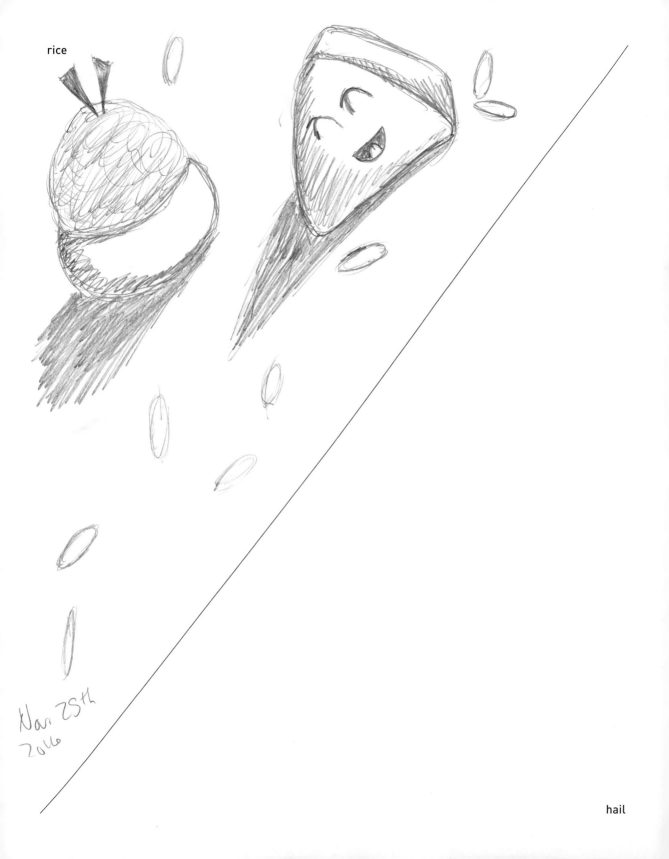

hail

Nov 25th
2016

a peacock

a croissant

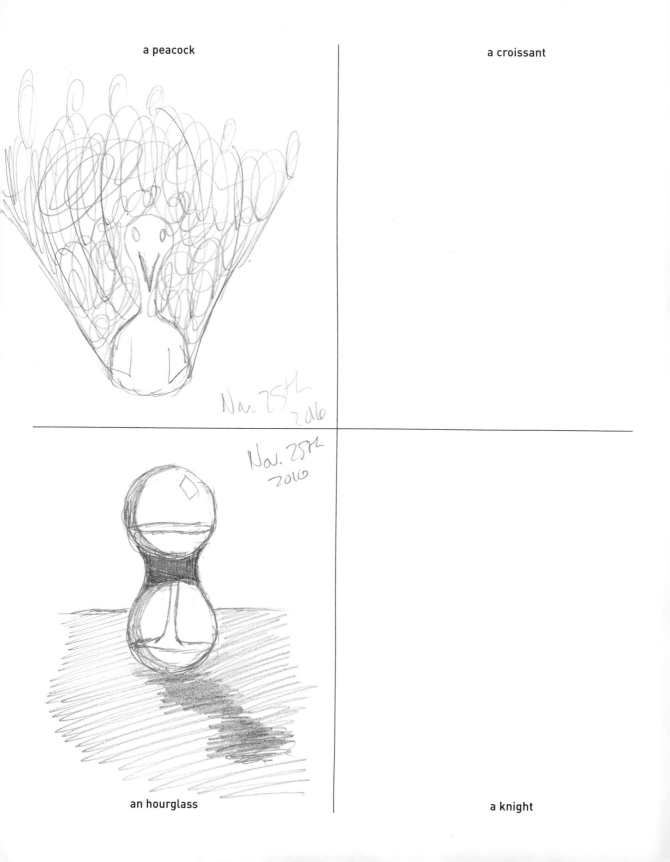

Nov. 28th 2016

Nov. 28th 2016

an hourglass

a knight

a kimono

a snow cone

a time warp

a ton

a blue lagoon

Sherlock Holmes

a hot tub

a cyclops

an avocado

a buoy

a tube of paint

a tightrope walker

a will-o'-the-wisp

a hairpin

an ancient temple

a trampoline

a mailman

a tub of lard

a silver spur

nostrils

fine china

thunder

frost

an astronaut

a carnivorous plant

Joan of Arc | a wishbone

a refrigerator magnet

a bar of soap

a wince

a jawbone

a solar system

quicksand

boogers

high tops

a dragon

a baby in a swimsuit

beans and corn bread

guts

a gentle giant

a fudge sundae

suspenders

a popsicle

a harpoon

nail clippers

a flying carpet

a bruise

the Vatican

a phoenix | a tornado

a minister

shorts

the eye of a tiger

masking tape

a wallet

a Christmas sweater

victory

a rocket

a trophy

a bald head

goggles

an oven mitt

a jungle gym

a mole

a banjo

a safe

a hard hat

Jupiter

a sea monkey

a burning bush

a sunset

a cricket

shoelaces

stew

a photo booth strip

a receipt

a garage

the old woman who lived in a shoe

a teddy bear

a bib

underwear

a geek

goose bumps

foam

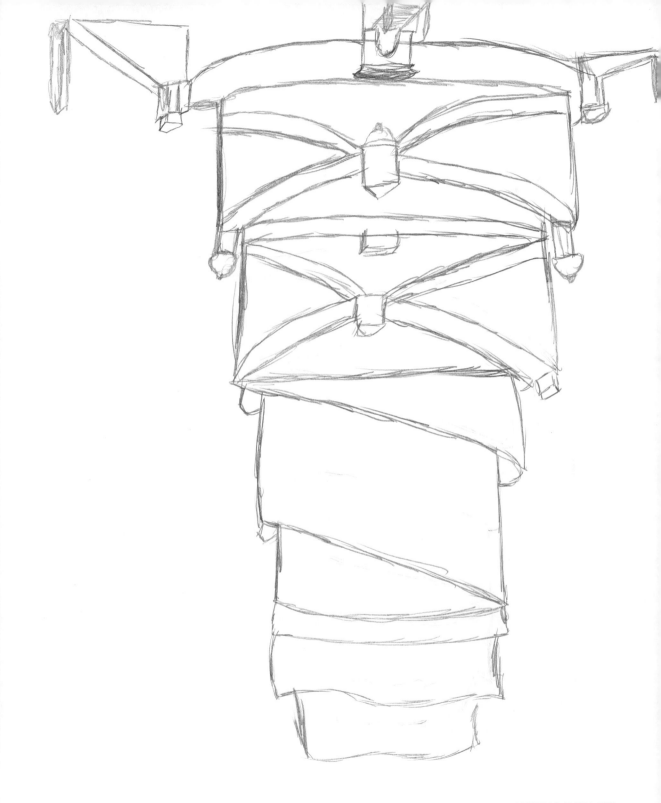

The Tower of Babel

a rattlesnake

a lily pad

a swordfish

a cottage

a swan

an orchestra

a booby trap

boxing gloves

a farmer

passion fruit

an egg timer

a caterpillar

a go-cart

a grenade

a skyscraper

a plumber

a canoe

a Sasquatch

a tea party

a vacuum cleaner

a cow

a thimble

shoulder pads

a clapperboard

a nutty professor

a taxi cab

a candy necklace

a wet blanket

a Bundt cake

an orchard

a supernova

a rain forest

a fallen angel | a fire extinguisher

a school portrait

a turtleneck

a clothespin

a toga

a chimney sweep

a marshmallow

a hookah

an ostrich

a croquet mallet

a television

a door knocker

a tricycle

an eagle

a tree house

a recipe

cat's cradle

a weeping willow

loose screws

a trail of breadcrumbs

yogurt and granola

a devil's advocate

sleigh bells

meatballs

Godzilla | a tripod

tumbleweeds

haystacks

a drive-in movie

a tidal wave

a royal ball

a stencil

a napkin

a name tag

a ball and chain

a party hat

an eel

a figurine

a camcorder

a bride

a spine

tug of war

an earthquake

a librarian

plastic beads

a jukebox

Captain Hook

a slingshot

a guitar pick

nuts and bolts

a gumball machine

traffic

a goodie bag

a lemonade stand

an armpit

a fort

dominoes

a locket

a crocodile

a cemetery

a skirt

an antenna

lungs

a zebra

a flask

a seesaw

an explosion

a boomerang

a wreath

static

sprinkles

heartbreak

a kaleidoscope

a phone tree

a kayak

water wings

a walk of shame

a pageant

a hockey stick

a maypole

Alcatraz

a bear hug

an ambulance

a basket case

a fiddle

a spatula

an ice sculpture

a toilet

a cameo

a wardrobe

summer camp

a pocket full of posies

sandals

a rabbit hole

puppies

a present

your breakfast

a cheese grater

a cartwheel

a rocking chair

a crib

a punk

a ninja

a news anchor | a mannequin

a recreation vehicle

a busy bee

a yawn

a fossil

a poem

a dollhouse

a postcard

bacteria

pea soup

a pipe

a barbeque

a monk

a socialite

three blind mice

a fortune teller

a pigsty

a sunburn

the belly of a whale

a fur hat

tweezers

a bat

licorice

a gadget

a license plate

a dungeon

a haunted mansion

a water skier

a bread stick

a lawn mower

Cleopatra

a bike pump

a fig

a vest

pebbles

a kiwi

an album cover.

a pinball machine

a projector

a pencil sharpener

a deep breath

a prayer

a visor

a growl

a caveman

dough

chopped liver compost

a gravy train

pheromones

crochet

a chinchilla

a tote bag

a cat toy

a doghouse

a watermark

steam

a flotilla

a kazoo

a marquee

a camel

a wrench

envy

hunger

a wig

a facial

a flying buttress

barnacles

a paper clip

synchronized skydiving

a zygote

a wind chime

a hunchback

a pinwheel

overalls | stilts

a shrine

a feast

a lazy Susan

a blue-footed booby

staples

a veil

a mask

birds of paradise

a butler

the Pope

a hernia

a woodpecker

a welcome mat

sad cheerleaders

a piranha

a blister

a birdbath

earmuffs

an arrowhead

dentures

laugh lines

a shovel

a joke

a puck

a taco

karaoke

a letter

trick-or-treaters

a chef

a stroller

ponies

a dog in a purse

a fact

a lie

a first step

a dart

a race car

Atlantis

cubicles

a shopping cart

a pet in a cast

a poker face

an eclipse

lacrosse

a laboratory

a genius

a revolving door

sequins

bullets

a magazine

Frida Kahlo

an octopus

a fleur-de-lis

an abacus

a museum

a force field

a piggy bank

a gingerbread house

a microwave dinner

a xylophone

a park ranger

a summit

a bush baby

a rifle

curds and whey

a casino

a lion

a dwarf

a bouncy castle

an awkward date

a fistful of dollars

a shepherd

a mortician

a light switch

today

a snake charmer

a lounge singer

a flamenco dancer

a prisoner

lasagna

stripes

a highlighter

batteries

an orange peel

fish food

a clue

a curse

poison

embers

petals

a coworker | a broom

paparazzi

a stampede

pterodactyl

second place

a raft

a chocolate bunny

deodorant

a squirt gun

an enormous sneeze

chicken and waffles

a shopping mall

barbed wire

celery sticks with peanut butter

coasters

a guillotine

a landslide

a cipher

a baptism

a stingray

okra

an award ribbon

a casserole

a trench coat

yellow pages

a motorcycle

a soufflé

an eye chart

tinsel

dreadlocks

drool

snot

a construction site

an engine

muscles

a catapult

a zeppelin

a belly button

a finish line

a mailbox

a headdress

a cuckoo clock

an eraser

a jack-in-the-box

a pacifier

your doppelgänger